Good i

iPhone photos by Mary E. Carter

Copyright © 2019 Mary E. Carter

I support copyright. Thank you for buying an authorized edition of this book and for complying with copyright laws by not reproducing, scanning, or distributing any part of it in any form without permission.

Mary E. Carter
ISBN 978-0-578-47022-1

TOVAH MIRIAM

www.Tovah-Miriam.com • www.Mary-Carter.com

Other books by Mary E. Carter:
I, Sarah Steinway
2018 WINNER New Mexico-Arizona Book Awards
FINALIST National Jewish Book Awards
A Non-Swimmer Considers Her Mikvah
2016 WINNER New Mexico-Arizona Book Awards

A Death Delayed – Agent Orange: Hidden Killer in Vietnam, 2017

Electronic Highway Robbery, 1996

Book Design: Gary W. Priester

Dedicated with love to my morning audience.

"One should have a good eye . . . and be a good friend."
—Pirke Avot 2:9

Every morning, along with my first cup of coffee, I pick up my iPhone and thumb through yesterday's photos. Then I text today's 'hero' photo to a short list of friends. And every morning I get a line, or a word or two, or sometimes an expressive emoji, in response to the day's picture. It's our way to stay in touch with each other without being too intrusive. Then, as I go about my day, I tuck my iPhone in my hip pocket and I keep an eye out for pictures for the next morning. We live in the northern escarpment of the Sandia Mountain Range in New Mexico, USA where even the dirt can be photogenic..

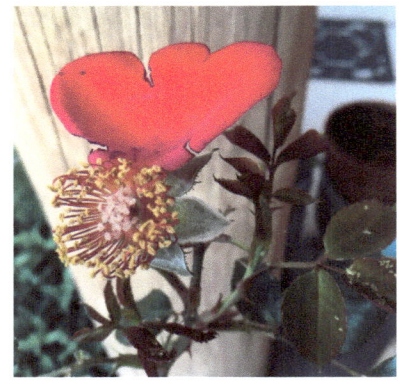

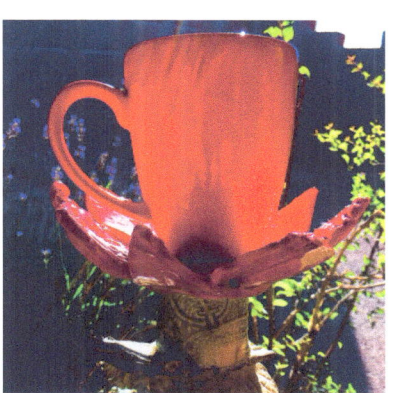

4

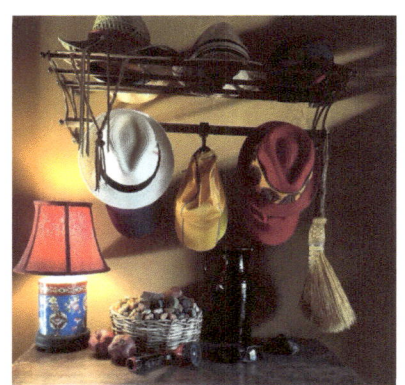

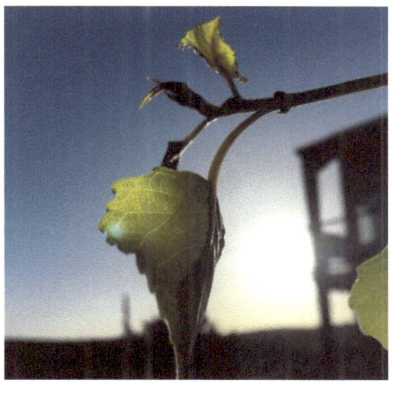

5

6

7

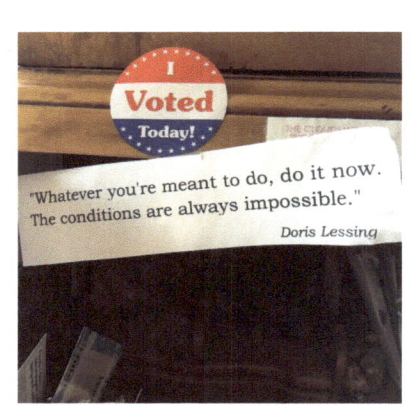

9

10

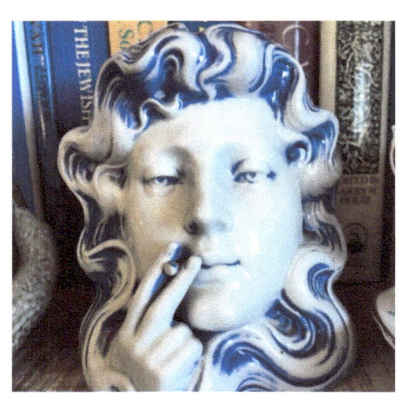

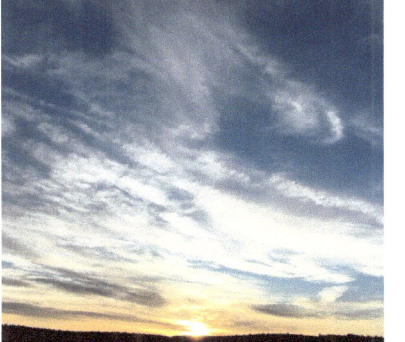

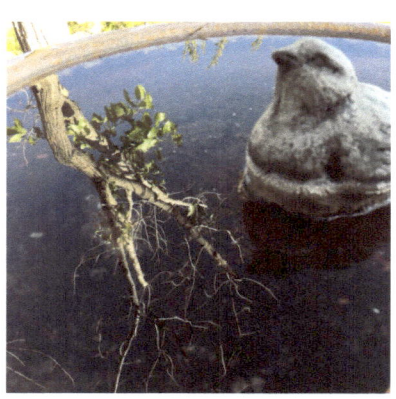

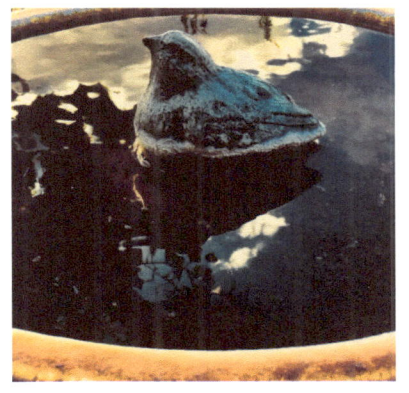

14

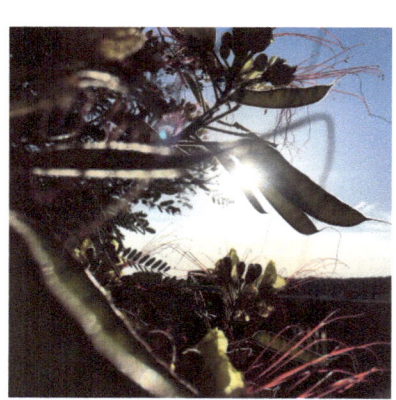

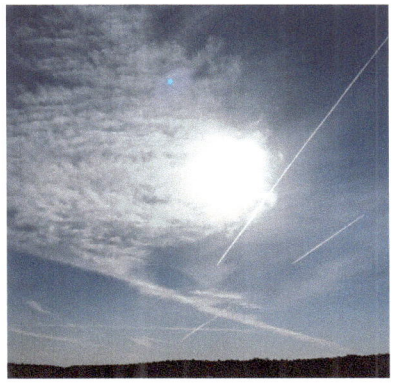

15

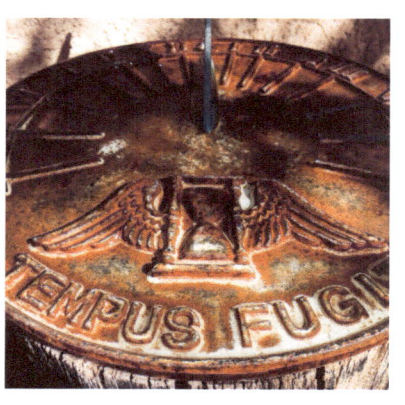

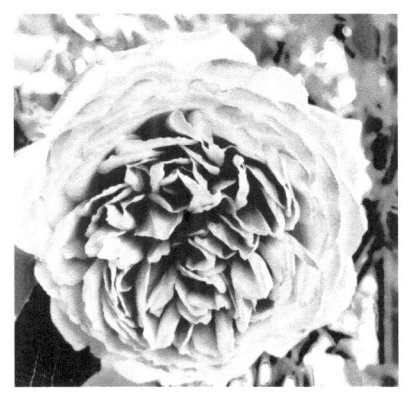

18

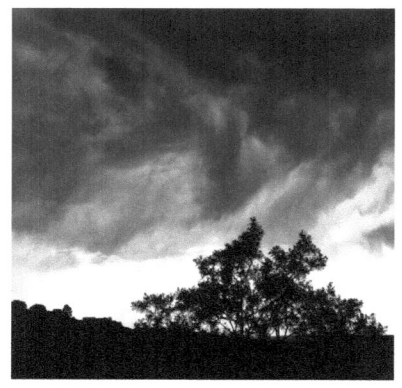

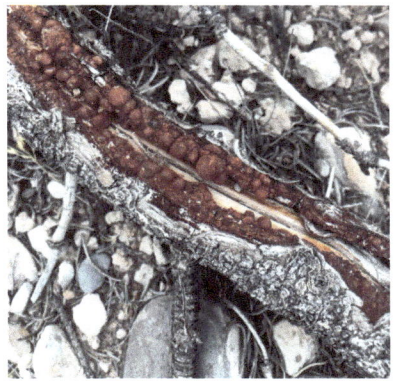

19

20

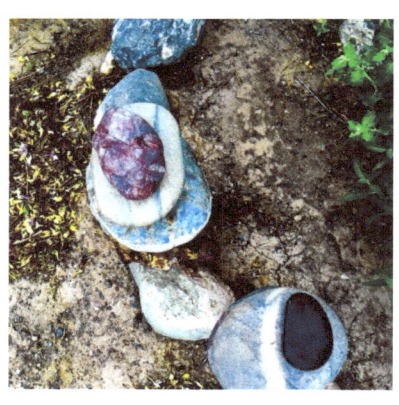

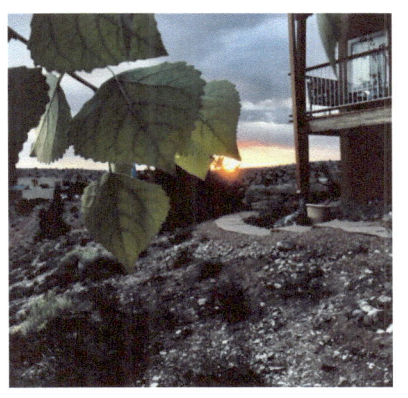

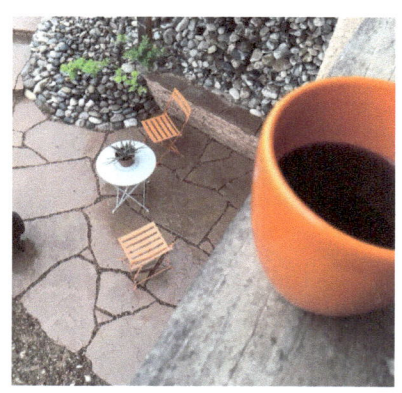

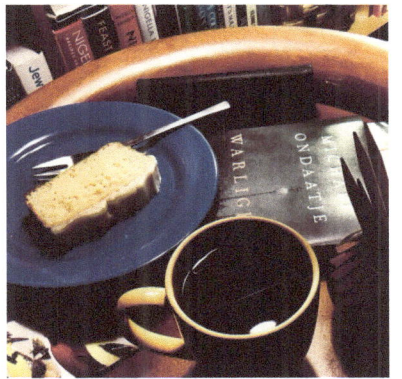

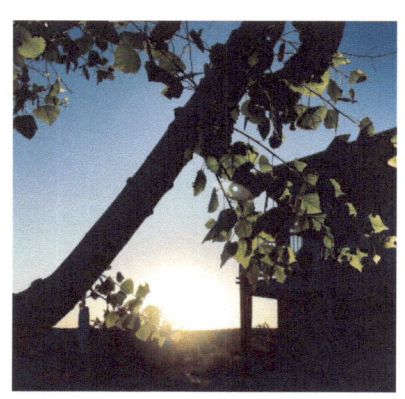

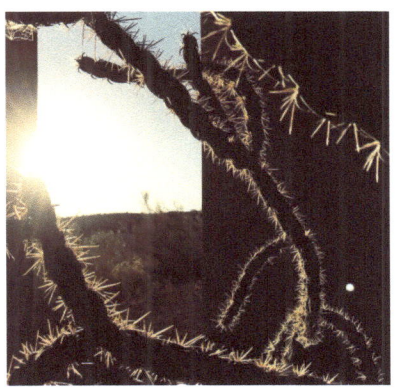

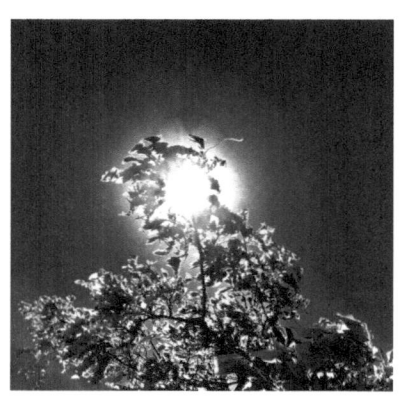

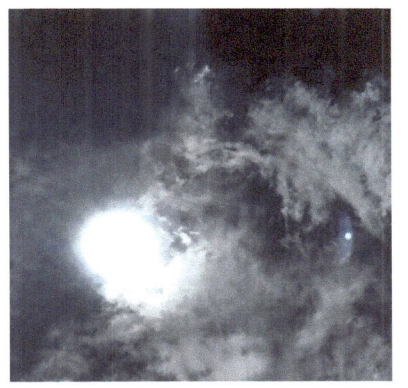

28

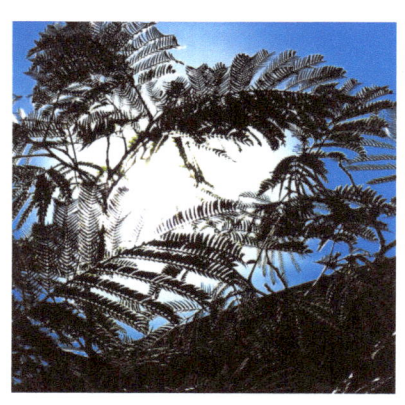

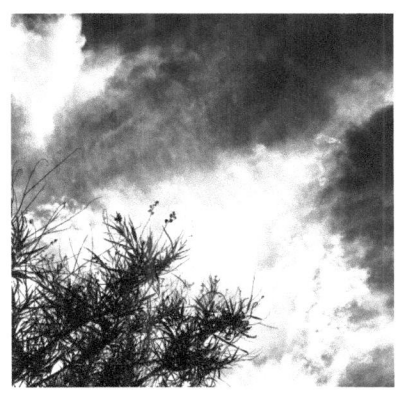

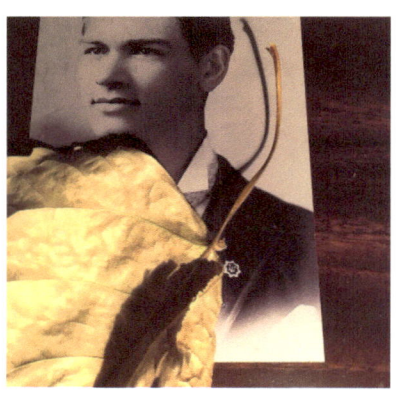

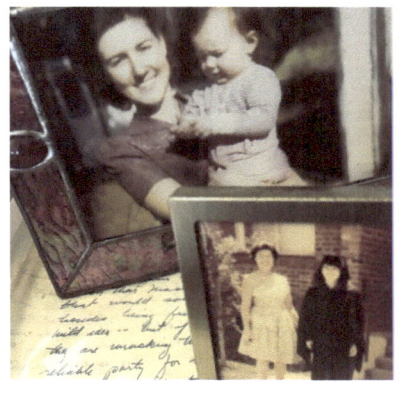

34

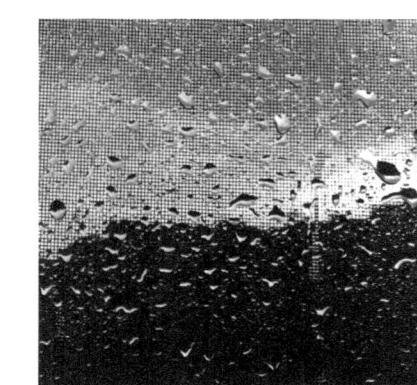

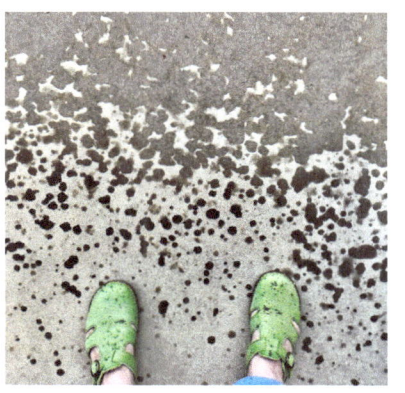

35

36

39

40

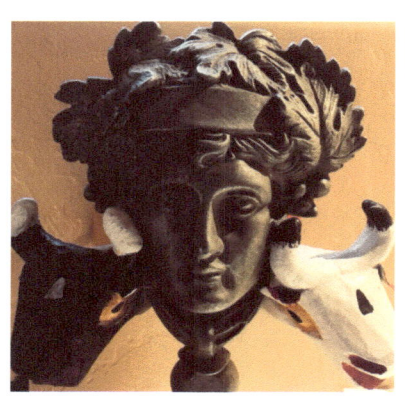

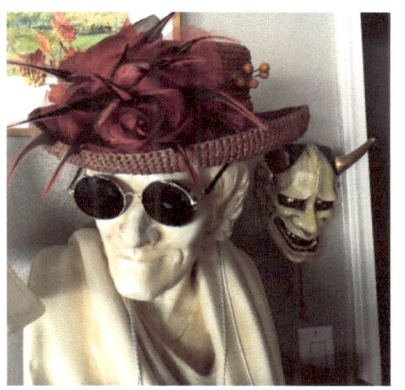

41

42

43

44

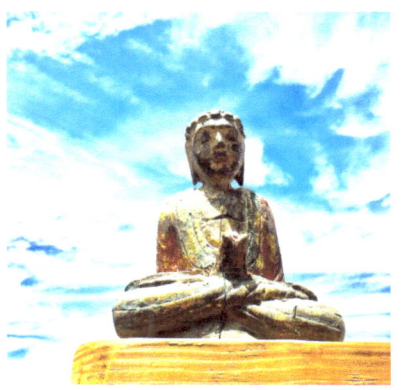

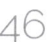
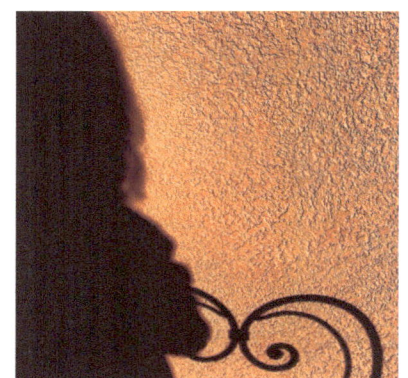

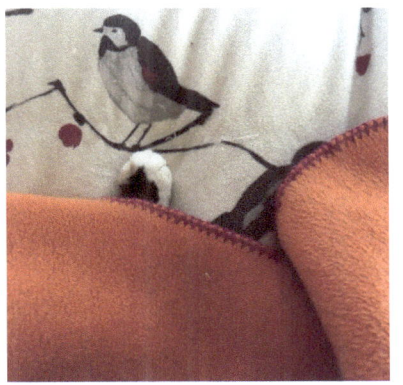

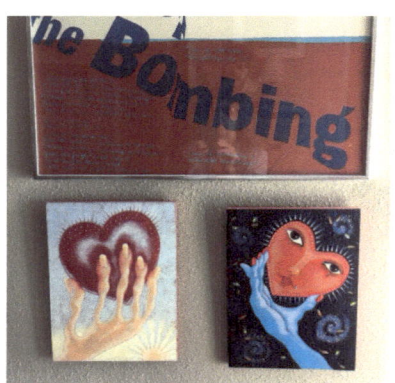

50

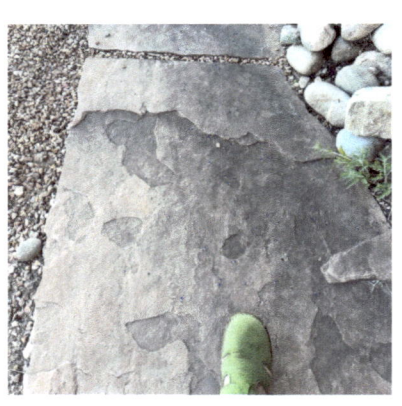

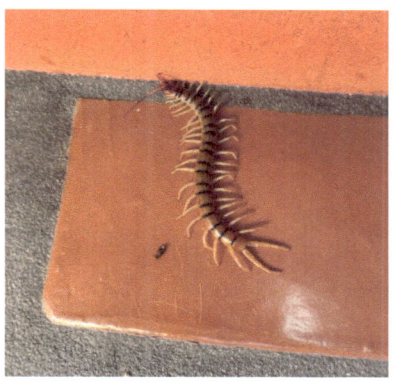

54

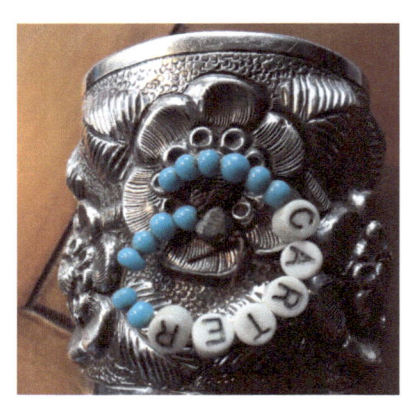

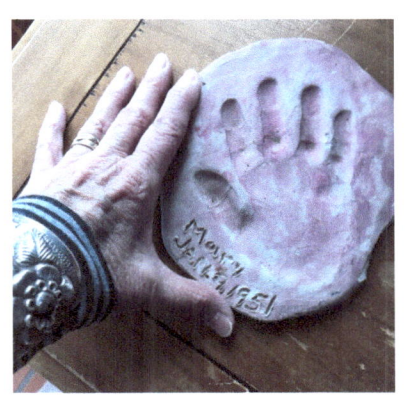

56

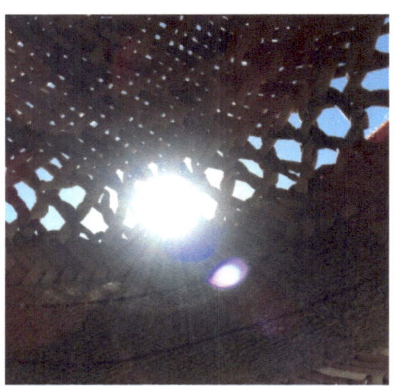

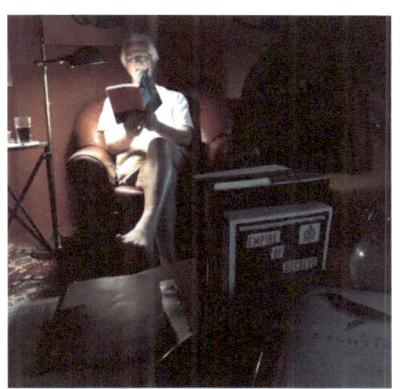

58

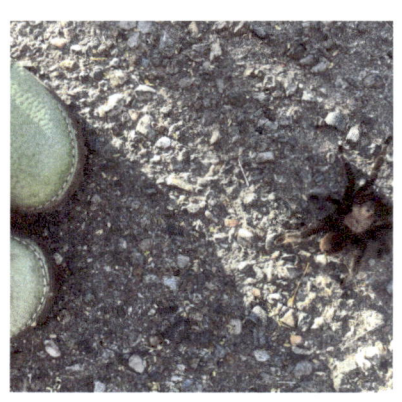

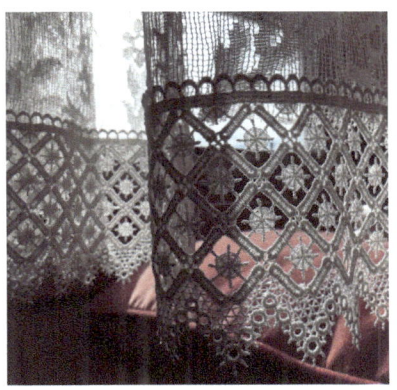

 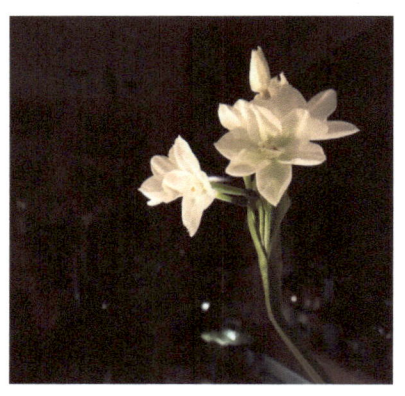

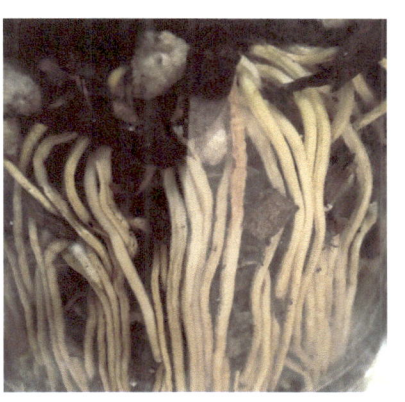

62

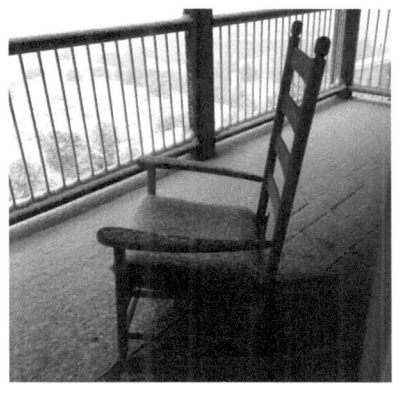

63

64

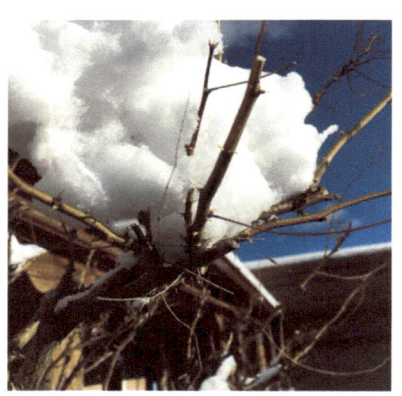

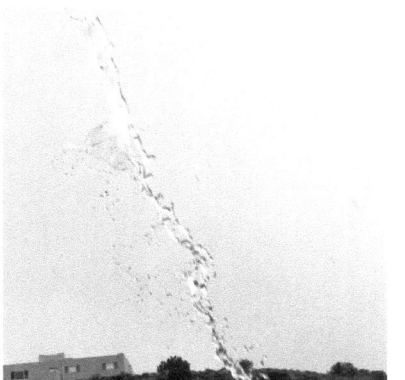

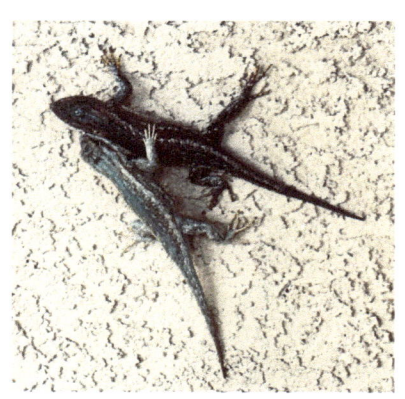

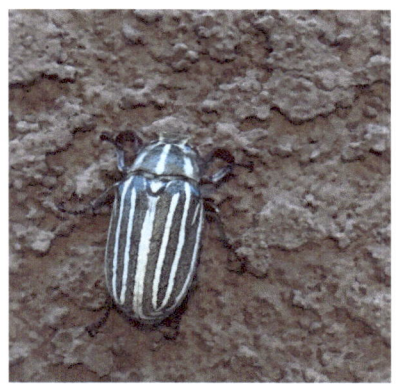

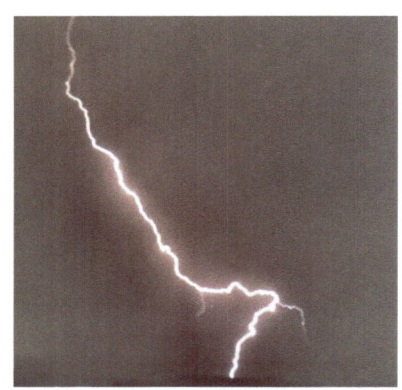

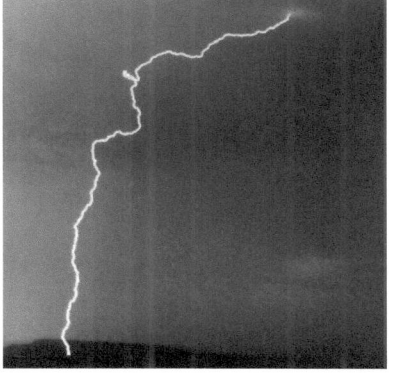

70

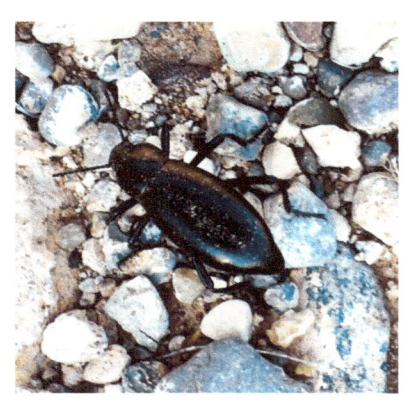

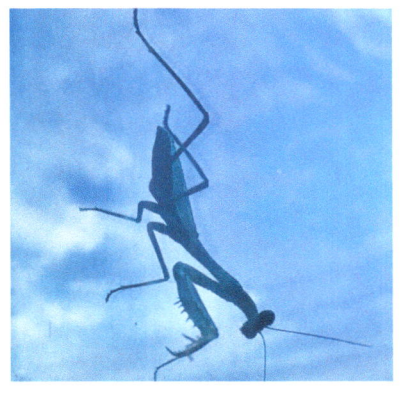

72

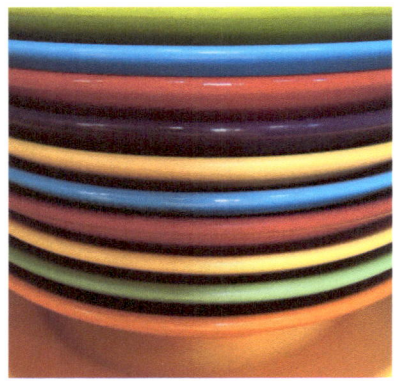

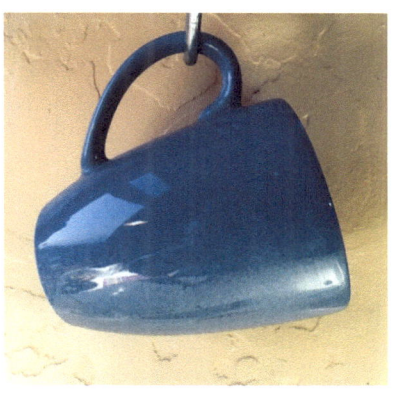

73

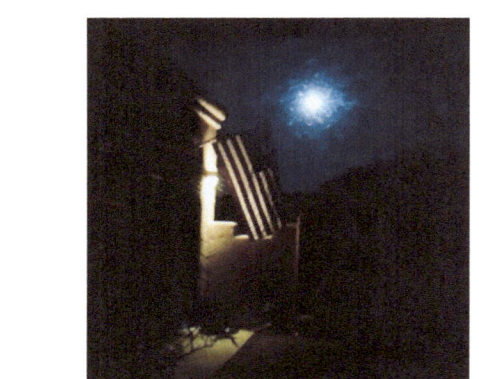

76

77

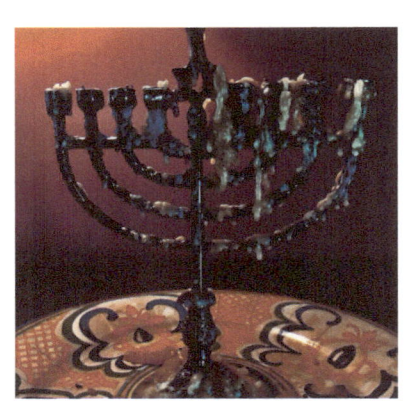

80

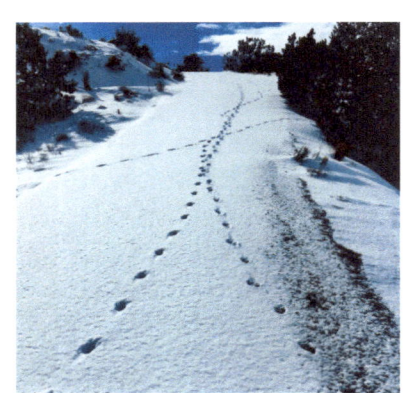

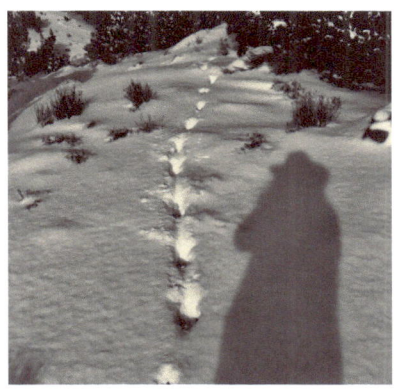

81

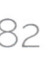

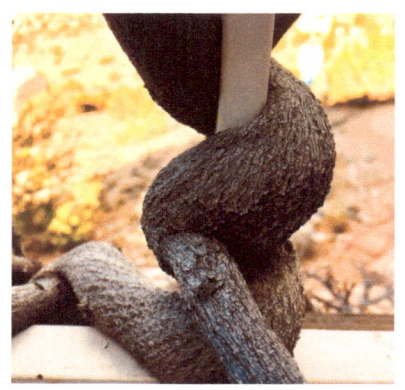

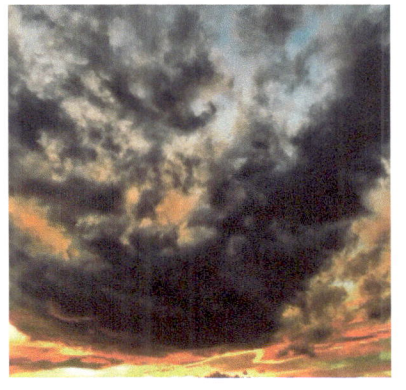

83

84

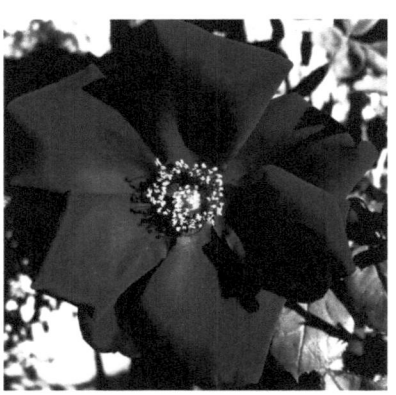

85

86

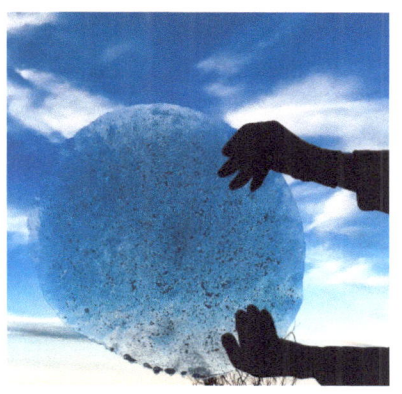 87

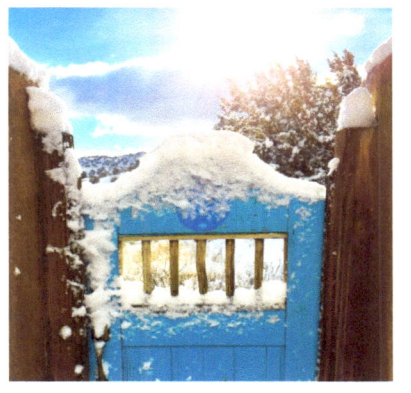

www.ingramcontent.com/pod-product-compliance
Lightning Source LLC
Chambersburg PA
CBHW051021180526
45172CB00002B/431